JOURNEY of CHOICES

A Collection of Poems
by Rieenna

Order this book online at www.trafford.com
or email orders@trafford.com

Most Trafford titles are also available at major online book retailers.

ISBN: 978-1-4269-1753-0 (sc)

Trafford rev. 01/14/2015

 www.trafford.com

North America & international
toll-free: 1 888 232 4444 (USA & Canada)
fax: 812 355 4082

To my Papaji, Biji, Mom and Rajat

A Rose About To Blossom

I love you, I tell you every day.
I don't know if you hear these words,
Dreaming that I am with you near the bay.
Smelling the scent of flowers, hearing the sounds of birds,
I just want you to tell me, You Love Me!

Seeing the ocean in your eyes,
Feeling the pain in your heart.
I am surrounded by people's lies,
I don't want us to stay any longer apart.
I want you to protect me and comfort me,
I just want you to tell me, You Love Me!

I see you sing and dance.
I don't see myself part of you.
I want to be with you in whatever you do.
I just want you to tell me, You Love Me!

You have given me so much.
Seeing you standing in a corner all by yourself.
I want to do something, only if you could feel better with my touch.
This pain is a torture and guilt in myself.
I love you, I tell you every day
I just want you to tell me, You Love Me!

Rain

The winds have begun singing louder,
The sky is laughing harder,
The darkness is taking more of the light away.
What kind of a miracle, no one knows, even till this day.

You can hear the music of nature,
You could feel the chill of this love.
You can see the trees and flowers dancing with joy.
What kind of a miracle has taken us aback with the magic?

I feel as though someone is filled with happiness.
I feel someone watching over us.
He must feel proud of our accomplishments,
And sad of our arguments.
What is this: a dream or reality?

When you begin to hear thunder,
You know that the trees will soon dance,
The darkness will soon take over,
There will be music to hear.

Hearing the drops on the roof,
Watching lights flash in the sky.
Everything is beginning to get wet.
Rain has come at last!

Thinking Of You!

I think of you
When worries are within me;
Pressure is building
Everything seems hopeless.

I think of you
Anywhere I go
In reality and
Even in my fantasies.

I think of you
At times when life has meaning,
Happiness has come after pain
When it seems I have everything.

I think of you
When I remember love is missing
There is a hole within my heart
My soul is laughing at me.

I think of you
Every time I breathe
Now, I wonder
When do you think of me?

Sensuous

I want to be loved,
With tender kisses and bare hugs.
I want to be flown off my feet,
With poetic words and soft caresses.

I want to see the sea,
Within someone's eyes.
I want to be the beat,
Within someone's heart.

I want to feel his breath,
Close to my skin.
I want to hear the words,
Close to my ears.

I want to sense his touch,
On my back.
I want to feel his body,
Across my thighs.

I want to refresh my memory,
With that loving feeling.
I want to remember it all,
Within my dreams.

I want to live life,
With him beside me every morning.
I want to see him smile,
Indicating that his sorrows are mine.

I want a complete life,
With all my hopes accomplished.
I want to die,
With him beside me.

I want to end my story,
While sleeping and thinking of God.

My Husband

He is the beats of my heart.
The breath of my lungs.
The soul in my body.
He is more than the ocean.
He is a mystery that no one can solve.

He is life and death!
He is the reason I live.
If He is no more, life is nothing.

Love is just a word, but
The meaning is a lot deeper than you and me.
Love is the treasure soul's search.
Love is the water that God drink's.

For Love, Death has no meaning.
For Love many have given their lives.
For Love many will!
Who are you and I in front of it?

What is Love?

Love is like a flower,
It soars higher than a tower.
Love is a feeling of joy,
It is not one's playing toy.

One can gain pain.
One can become insane.
Life can become hard.
It can be like a game of cards.

There can be happiness and fulfillment.
One does not have to pay any instalment.
This is the beginning of a life relationship,
Life begins to draw roads to a very healthy friendship.

When does one know one is in love?
One knows when one always sees doves.
The world would seem beautiful to them,
Everything would be bright and shining like a gem.

Love is something that never dies,
It brings two people together and there are no lies.
One feels as if one is flying high in the sky.
One is always filled with joy, there is no time to cry.

One always sees the other person's face,
One wants to run to the other person at a fast pace.
One feels the pain in being lonely,
That makes them face anything that's in their way more strongly.

There are no limits to this feeling.
No one ever really understands why someone seems appealing.
Even when the two people are no more, love lives beyond that end.
Love can never be ceased, but can forever extend.

Heaven

Bright light,
Colourful flowers,
Trees soaring high,
I, in the middle trying to reach the sky.

I want to be part of the world
Where life is life and not death,
Where I can reach my goal
and not just see it.

I lay in my bed
With thoughts in my dreams
I want to reach the top
Be successful and be known

I don't want to die without
Knowing how the world looks.
Without seeing the beauty made by Him.
I want my life to be like
HEAVEN

I Am

I am a poet of a few words;
My eyes tell my story.
I am a writer of a few lines;
My smile says my experiences.
I am a friend to a few people;
They are the voice of my achievements.
I am the lover to one guy;
He is the shadow of my soul.
I am a weaver of a few dreams;
They show my inner strength.
I am the creator of my own destiny;
It will be known after I'm gone.

Life

Life is full of adventure
Where things don't seem the same.
A place full of surprises
Where nothing is achieved within a small range.

There are times to be happy
And times to be sad.
Sometimes you don't know which one.
However, life does have it's good times and bad.

Life will give you opportunities
And will give you chances.
At times you'll run after what you really desire.
Other times it will give it in your hands.

Without getting hurt by a thorn,
One can't pick a rose.
One might fail at first
But, one should not give up and try, try again.

Life is full of colours,
But there are channels of black and white.
Life if full of dreams,
But there is reality, which bites.

There are chances of success and fame.
Opportunities for wealth and luxury.
Sometimes when things don't go your way,
You are left with nothing except harmony.

One needs confidence and will to succeed.
Needed is courage and bravery.
Life is not a yellow brick road,
It has many other colours, a truck full of this load.

Who will succeed, who will fail?
Who can learn from these mistakes?
There are no guarantees and deals.
You must fight life in order to turn your own wheels!

A Journey, A Ride

Life turned against you,
People left you too.
You seem confused and lost.
These feelings could lead to a huge cost!

Must prove that you're somebody.
Get help in anything from anybody.
Lost in a crowd of many faces
No one here will find your traces.

Look at your life in a view that's broad.
Must not trust, for everyone is a fraud.
No one will help you in anything,
You must do by yourself; everything.

Life is filled with ups and downs
But one has to wear one's own crown.
Taught are many lessons
A belt that God fastens!

You have to set your own goal
In order to fill your own bowl.
One must focus on an aim
For life is similar to, "No pain, No gain!"

There are many stages
Some seem like huge cages.
But, there is only one road
The one, God showed.

There will be many curves
You must prepare your nerves.
There will be tears as well as laughter
But you must learn to take things softer.

Life is a ride; a journey
Your dreams are the goals set highly
Decisions are your turns
Problems are lessons to learn.

Everything has to occur for a reason.
Nothing happens until its time; it's season!
Thoughts are the seeds for the future
You are your own teacher.

Life has no meaning,
Not until you put some seasoning.
All does not seem the way it looks
Imagination is a whole new dish to cook.

Your life depends on you
It's a challenge, a game too.
Truth lies within each one of us
Who finds it is a surprise as such.

There is an answer to every question.
You must search for it with true affection.
Motivation and determination plays a big role,
These are your buddies in the journey of your soul!

You are a legend, a story
To the One who looks down in such glory.
He is the goal to our existence
Life is a token, which everyone passes in an instance.

Life means a person with a huge imagination
For it's you who puts a meaning of illumination.
There is no end to such a word
It's like a flight of a bird!

If you close your eyes
You will see many ties;
An ocean with waves
And a place with caves!

Secrets every person keeps
Sometimes you can't sleep.
Times where work is all
To cover pain with a shawl.

You seem adrift
In thoughts that shift.
A face with experience
That some day will give great influence...

A Bird

It's been 12 to 13 years
I've been tied in a web
Caught in a cage
Held by the world!

I ask for freedom,
Fresh water and cool winds.
I ask for love,
Happiness and understanding.

I have dreams of a person,
God or a lover, friend or a stranger.
I have nightmares of a fire,
Burning within my soul, my heart.

I have many goals,
A future bright and tall as a totem poll.
I have many thoughts,
Sometimes help and other times disturb me from
Reaching where I see myself tomorrow.

I now understand,
I need someone to talk to.
I know now,
There is no one out there for anyone of you.

I am losing touch with myself,
I am fazing within my own soul.
I am becoming a shell
Filled with someone else's expectations.

I've heard people say,
"Dream, but don't expect them to come true."
I've heard people say,
"Anything is possible."

I've heard people say,
"Destiny is what you make of it."
I've heard people say,
"Life is a journey."

But who has said that,
Responsibilities are part of this journey.
But who has said that,
Sometimes one's life becomes one's cage.

Who can tell
Where one has come from.
Who knows
How far one must travel.

This could be all a joke,
 A drama watched by God.
It can be a nightmare,
Watched by our minds and not our eyes.

It's been 12 to 13 years
I've been tied in a web
Caught in a cage
Held by the world!

Nightmare

Darkness in all corners.
Running from one's fears.
Remembering the past,
Worrying about the future!

Not knowing where life is going .
Feeling lost every day and night.
Caring about nothing,
Worrying about everything!

Life has become a mystery.
Every corner is a surprise.
Following only one path,
There doesn't seem to be any other!

Everyone's interested only in their own life.
No one seems to love you any more.
You try to find that someone special,
It always feels as if he disappears!

Where to go now.
What to do next.
There doesn't seem to be any answer,
Except there is only one thing left to do!

You tried drugs and alcohol.
Sex didn't feel right.
You tried gangs,
You tried guns and knives!

Streets seem to be homes for many,
But you want to be different.
You don't need anyone any more,
There is no one worthy for you anywhere!

You are walking your own path.
God doesn't seem to stop you.
Coming towards a bridge,
Waters are washing away your pain!

You feel cold,
But soon warmth will come.
Everything is blurry and not real,

You know you reached somewhere special!

There was only one solution.
Now all will love you .
Now all will remember.
But you tend to wonder...

Why did everyone care
Only after you committed
SUICIDE!

Depression

Standing in a corner all by herself;
Listening to music, radio on her shelf.
Waiting for someone,
Hoping that he will come now.

Scared, a fear within her heart;
She does not want to grow alone or apart.
Learning slowly by experience.
She now knows, she needs obedience.

Loves adventures and thrills,
Can't wait till any more drills.
Snow is falling to the ground,
She is losing herself in the crowd.

A slap on the face was hard.
Now, life seems like a deck of cards.
She knows she will climb again.
The staircase will lead to her gain.

After darkness comes always light.
After production, the plane goes to flight.
But, darkness seems to come again.
Many planes seem to go in flames.

What once was, has gone forever.
This pain is still here, however.
Tired of the desires of the world.
The rose has now curled.
The rose has now died!

Help

The echo is fading.
Clouds are forming.
It's about to rain.
Thunder has made its sound.

She is standing at the edge
Wondering whether she'll fly
Or will she die?
Her mind is playing a trick.

How long can she last
Before she goes down.
How long can she cry
Before the tears dry.

She cries for help
But no one hears her.
She wants to change
Learning that she's alone.

She tried to be the best
Daughter, sister, friend.
She tried to be the best
Person, human being.
But she is now tired.

She just wants to be herself!!
Help! Help! She's just very tired!

Finding Oneself

I have now found myself.
But, I am lost in life.
I am knowledgeable of many things.
But, confused about much.

I have now found myself.
But, yet there is much else to discover.
I am an independent lady.
But still seek aid from Him.

I have now found myself.
But the process has impounded harsh lessons.
I am confident I will gain happiness.
But, scared I will also see much sorrow.

I have now found myself.
But, many dreams are still chased.
I am a unique individual,
But similar to others in many ways.

I have now found myself.
But, I still need to reach the top.
I am clear and certain of many ideas.
But I am a complex person.

I have now found myself.
But, I am lost in life.
I am knowledgeable of many things.
But, confused about much.

Confusion

There is much out there.
Sometimes life is hard to bare.
There is so much to see.
It is hard just to be.

There are many places to visit.
Life is memories that are very vivid.
This all seems like an illusion.
A soul filled with much confusion.

Who am I?
What do I want?
Where am I going?
Why am I here?

You see two sides of life.
Make sure that neither bites.
It's a web full of craze.
Seems like you're in a maze.

Darkness is filled with fears.
Emotions that lead to tears.
Brightness is a bucket of hope.
Making life possible to cope.

Who am I?
What do I want?
Where am I going?
Why am I here?

There are many people you meet.
Their stories you get to peek.
Everyone has same lessons to learn.
Each choice has a new turn.

Life is filled with many questions.
Each person has his/her own opinions.
You must make your decisions.
That can lead to many confusions.

Who am I?
What do I want?
Where am I going?
Why am I here?
Life can be quite simple.
If you don't mix others waffle.
You must learn to be alone.
For no one in this world comes along.

To aim for a life of success.
You must learn to confess.
People can be quite cruel.
Seems like you're always playing a duel.

Who am I?
What do I want?
Where am I going?
Why am I here?

Everyone has their own life's definition.
Just make sure it's not one long competition.
For each finds their own path.
Live it to the fullest to win the match.

Sometimes things don't seem to go your way.
Make sure you still follow your values every day.
Happiness is right around the corner
Patience can lead to that border.

Who am I?
What do I want?
Where am I going?
Why am I here?

Choices determine your path.
Each leads to a different catch.
Life's too short to fear other's opinions.
By winning your heart, you become a champion.

This life as we know it, is an illusion.
Life's a passage: to separate yourself from this by great determination.
Winning over your heart is a challenge.
Must learn that everything should be a balance.

Who am I?
What do I want?
Where am I going?
Why am I here?

All are busy determining who they are.
No one has time to worry about others or care.
One is more than just ones accomplishment.
Looking within leads to enlightenment.

Determining your dreams is a grand process.
For some reaching them is obscurant.
Work is done to reach these goals.
Life however never seems to have an empty bowl.

Who am I?
What do I want?
Where am I going?
Why am I here?

One goes where life leads.
Road taken is decided by one's deeds.
Each has own desires of places to go.
But, you end up where you're suppose to take your last bow.

Reason for being is never determined.
But, people rarely ask this question with conviction.
Each does one's own tasks in life.
At the end, it's good-bye to all with lips closed tight.

Who am I?
What do I want?
Where am I going?
Why am I here?

Life of Many Meanings

Life is a stream.
Life is an ocean.
Life is a river.
Life is the way you see it!

Filled with flowers.
Filled with thorns.
Filled with sand.
Filled with stars!

It's a stream of hopes.
An ocean of dreams.
It's a river of death,
But it's a heart with feelings!

Life is a challenge.
Life can be heaven.
Life can be hell.
Life is the way you perceive it!

It has many risks.
It has many choices.
It has many memories.
It has many doors!

It's a challenge for the winners.
Heaven for those who dare to dream.
It's hell for those who are losers,
But life can be eyes for all to see!

Life is a path.
Life is a road.
Life is a highway.
Life is what you make of it!

With waves of opportunities.
With a bridge to many worlds.
With an imagination that knows no limits.
With rains of luck beside you at all times.

A path to your goals.
A road leading to your future.
It's the highway to your destiny,
But it's a window to make you whole!

Life is in your hands.
Life is in front of your eyes.
Life is only because of you.
The way you want to live your life is up to you!

A Journey

Life is a path
Taken one day at a time.
Life is like a match
Where the rules are to be known.

Life gives you four chances.
You must learn not to fail.
It is like a ball game,
But in this case: 4 strikes and you're out.

Learn to have fun in youth.
You learn to laugh at yourself.
Make as many friends when young;
You'll soon forget the meaning of 'innocence.'

Make a map of yourself for direction.
Teenage hood is a path with many misconceptions.
Learn to walk faster than the world;
For it might eat you alive at the next curve.

Keep a track of your goal.
People know how to sell your soul.
Fasten your seatbelt tight.
Adulthood is like one huge fight.

At last, you've reached your peak.
You're life is about to be complete.
It is time to learn about yourself.
Old Age shows life as a wheel and a picture of your inner self.

Life is like a plane
Which can fly only with your brain.
Life is like your eyes
That shows you it's larger than the skies.

Life can be seen as a drama
Where you as actors, put in the stamina.
It can be like a dream
Slowly growing to become completely free.

Ambition

Dancing with joy
Excitement within your heart
Knowing life is a struggle
Having someone brings adventure

Coming closer to your goal
Seeing the world in a new perception
Wanting to go home
Not knowing where home is

Someone to walk you to your goal
Someone you could talk to
Trying to reach the sky
While your feet are on the ground

Feelings of thrill
Feelings of laughter
Feelings of mystery
Taking one day at a time

Treating life as a game
Making the opponent go to shame
Even though you'll lose some
You'll know you will win some!

Competition

It seems impossible, in the beginning
To go after what you desire endlessly.
But, you don't seem to give-up.
Knowing that hope will give you a whole lot of stuff.

In order to get to the top.
You sacrifice sleep to this sort of manufacturing shop.
Working hard day and night,
Hoping that one-day on you the sun will shine bright.

On this mountain, during the climb,
You meet many devious slimes.
At first, you're scared of what to do.
But soon you learn to play their game too.

It seems like a war among one another.
Then again, Earth is a hostile territory where we all live together.
Learning to fight is very crucial
As you won't find time for a commercial.

It is a fight to see who's a survivor.
And who can for their own plane, be a good aviator.
It is not a race to the end.
This is a test to see who with others can blend.

Learn to take one step at a time.
Make sure you don't go blind.
It is rough in a wilderness filled with lions and snakes.
Learn to be wise and clever, but don't close your heart and only take.

If the world can offer all sorts of wars and battles
It can also offer peace, happiness, beauty and a saddle.
You don't have to ride your horse alone.
There is always someone for each and not a clone.

If on one side there is the Devil, on the other there is God.
Learn to trust your instincts that which is a special bond.
You can never lose when you have yourself to believe in,
And if you know it, don't commit that sin.

Remember, this world is an illusion of our minds.
If we came alone, we will go the same way, nothing one finds.
Therefore, live your life to its fullest.

You might wait for the clock to quickly turn, when you feel dullest.
But, time has no heart; it won't wait for anyone.
Make every day worth it; after all you are a someone.
Be a master of your own destiny
Know what your goals are and don't let anyone come in the way of
ecstasy!

Determination of Glamour

Stars twinkle at night.
During the day, they go out of sight.
The sky seems to be their limit.
One chance is all they need to prove it.

You are the icon of this era.
At last, you have found your kinara (corner).
This fame is short lived,
But the dream is sure fixed.

You must still learn
Your body must not burn.
Don't worry about what others say
Just enjoy and relax near the bay.

This is written month after month.
I can't stop from being blunt.
The glamour life is my one goal,
But I will need to give my whole soul.

Sometimes I want to reach the sky.
Other times, I am afraid to fly.
I don't know where to go.
I don't know what to do or show.

Life is like a wheel of fortune.
I want to go further than Amitabh Bachchan.
There are only two obstacles holding me back.
Opportunities and confidence is what I lack.

Dreams come to all.
Some learn quicker to crawl.
I have a long staircase to climb.
At the moment, I feel I am walking blind.

Life seems so short;
There is so much to do, one can't abort.
Happiness and sadness are part of this package.
One must learn to use it to one's advantage.

I feel I don't have the looks.
Also, I haven't read the right books.
There is so much to learn.
One must in turn be stern.

The glamour town is a place of wonders.
It sometimes reminds one of thunder.
People there teach one the harsh meaning of life.
Seems, as one's neck is always under the knife.

But, thousands are trying to find films every day.
Though, no one knows what to say.
Is it money, fame, success or glory?
Everyone has his or her own story.

There are always ups and downs.
No one for long wears the crown.
One either becomes a legend forever
Or one ends up where one began, reaching nowhere!

Some are hot as the fire;
Faces are on the front cover of every flyer.
Others are cold as the ice;
Their plans were not thought of twice.

This industry is like a maze,
One never knows where one will end up in a daze.
Learn to stand up quick on both feet
Or one will be biting ones own teeth.

Everyone has a different way of thinking.
Use every minute of the day wisely before sleeping.
It's tough being on one's own.
That's how one learns to live by one's own tone!

Glamour Or...

Life seems to shine from far
People hang out and drink at the bars.
Their faces bright with a smile.
No worries, others taking care of their files.

You treat them as role models and Gods
However, there is more to this, you discover many frauds.
Our eyes have curtain of lies.
Discovered are their lives full of knots and ties.

They all live in their own fairytales.
The Real World is quite different; they would in it, fail.
Everything they are is not what you want
Those things would haunt.

Materialistic things are all that they desire.
A world where the Devil is the only survivor.
Where everyone lives for him/herself.
All that is good just melts.

As you should never judge a book by its cover;
Don't expect to find a lucky clover.
It is one strike or you are out.
People here are cruel and always in doubt.

There is no true love or trust.
If you are not strong, they will crush.
Either fight your whole life
Or get out quick, before you are stabbed with a knife.

You do learn a lot about the ways of the world.
But you must open the things that are curled.
No one will serve you in your hand.
You must go out there and make a stand.

All you need is confidence and perseverance.
Then watch to see how things go with your appearance.
Life has many ways of teaching us the same lessons.
Just sit and learn with happiness, the latest fashion!

Future

When I reach for the stars,
They seem to go further and further away.
When I try to cross the river,
It seems to get wider and wider.
When I climb the stairs,
My goal seems to get higher and higher.
When I walk towards the door,
My destiny seems to get harder and harder to reach.

Is it my imagination?
Or is it a reality?
Will I not reach my goal?
Will I not know my destiny?

Life has its ups and downs.
A river with many waves.
A path with many rocks.
A rose with many thorns.
Life is a challenge to pass.

If life was a game,
It would be a game of chess.
If life was a mountain,
It would be the Rockies.
If life was a fruit,
It would be an orange.
If life was a person,
It would be you.

It's up to you to build life.
You make the moves.
Through your strengths, climbing is easier.
You must first peel before you taste.
Life is what you make of it,
Destiny is only in your hands!

Life is Like....

Life is like a sea of knowledge.
It comes and it goes.
A circle filled with dreams,
But death for a challenge too.

Life is like the wind rustling through the leaves,
Whistling through as it passes.
Saying something,
Yet not saying a word.

Our world is so deep,
All the answers are in front.
But, we haven't even found ourselves
Or even understood our other half.

Lost in a world of technology
Where the question "why" is seldom asked.
There is so much to life.
Nevertheless, eyes seem to follow the green much.

Life is a game of chess
Every move is vital
It is addictive like a drug.
Teaching to take risks and improving many skills.

Life is a path of thorns
Seldom are flowers found
It is a risk to all
That few manage to beat.

Hidden In Life

Hidden within each
Someone for thee to teach.
Learn to be yourself;
Not to be someone put on a shelf.

Life is in our hands;
For your dreams make a stand.
Life is too short;
Don't waste it on others, that route you must abort.

Create havoc for all to see.
Life is a journey for you to believe.
Don't be like others, a follower.
Be the best in your life, be an ambassador.

There are so many things to experience;
We can see all; the will is within each one of us.
There is such beauty in this world,
Don't just look at pain and suffering, together curled.

The prairies, the mountains, the desert and the forests.
Together they all sing a beautiful chorus.
The water, the sun, the wind, the earth, and fire.
Doesn't it make you want in life to fly higher and higher?

Your dreams and your hopes make you go on,
The family, friends, and love make you stay strong.
Your goals are your destination
The determination, motivation, and will power are your ammunition.

There are no problems in your life.
Only those that you create which cause fright.
There are only two things humans are scared of:
Noise and falling should be of concern that you should shove.

As you can see, life is a train.
Don't stop until what stops is your brain.
Life can be seen as an apple.
Don't eat anyone else's, just drink Snapple!

There is too much to do, don't whine.
Just don't worry and take things a day at a time.
Let God handle the main changes,
You'll realize that everything rearranges.

Problems are created by your imagination.
Your job is for those problems elimination.
All the pieces of the puzzle fit by the time you're old;
Just follow the waves and be bold!

The Strength Of A Mother

When life seems an endless journey.
When trouble seems to be a goal.
When giving-up is the only answer.
You are there to inspire us!

When we are lost in this world.
When we worry to no end.
When tears become part of our daily routine .
You are there to show us our future!

Mother has a special value,
The confidence to go on.
Mother has a special meaning,
The strength within every one of us.

When our heart breaks.
When our dreams seem to shatter.
When the pieces seem hard to put together.
You find a way to build our hope.

When death creeps up.
When sickness control us.
When our beds seem our faith.
You find the time to take us to a doctor.

Mother has a special value,
The confidence to go on.
Mother has a special meaning,
The strength within every one of us.

When the world goes against us .
When no one believes us.
When we can't go on any longer.
You take our side and fight with pure strength.

When we are confused and indecisive.
When we have so much to do and complete.
When we try to do all at once.
You show us to take one day at a time.

Mother has a special value,
The confidence to go on.
Mother has a special meaning,
The strength within every one of us.

You are the light that shines within us.
Your qualities show in our work.
You have respect from God, Himself.
Life seems to be in your hands.

You don't give-up to thunderous weather.
You take the paths that seem the hardest.
You have the courage that outshines all.
You have built the strength of a MOTHER.

Mother

Mother - a name given to a woman.
Mother - a name with great respect.
Mother - a name of great value.
Mother - a name filled with love.

You are our inspiration,
The person we look up to.
You are our destination,
Where we end up after a long day.

Loyalty, honor, trust,
Love, confidence, joy
Are merely a few words.
These are only a few qualities within you.

Mother - a name given to a woman.
Mother - a name with great respect.
Mother - a name of great value.
Mother - a name filled with love.

Mother Indira

A woman we cannot forget,
She's the one to win each bet.
In her life span, she saw it all.
She went from top to a fall!

The first woman prime minister.
The name Indira Nehru was given to her.
Born on November 19, 1917.
She was a woman: bold, strong, and keen.

Like a goat, climbing towards her goal.
She wanted freedom to India and to all.
Lived through the time of the British rule.
Her father was Jawarharlal Nehru.

She travelled a lot with him.
He was the first prime minister after a decade of dim.
Mostly studied politics and history at home.
Her parents went to jail for the Congress party, their dome.

She fell in love with a man named Feroze.
Her studies at age twenty-five, froze.
Married on March 16, 1942, too soon.
It was said, the marriage was a doom.

After the honeymoon, they came back in politics.
She got too involved, arose were family conflicts.
She helped her father in the Chinese border crisis;
China was going against the treaty of friendship: no border traces.

Two other problems rose: Kashmir and Madras.
Pakistan wanted Kashmir and to expand their borders further across.
Madras was burning from mobs and violence,
Indira Gandhi intervened, Madras was once again silence.

Gave birth to two boys, in 1944 and 1946.
Their names were Rajiv and Sanjay, what a mix.
Tension at home rose once more.
Feroze Gandhi died in 1960, he travelled alone across the shore.

Jawaharlal Nehru died in 1964.
She lost the seat of prime minister, Shastri came to the core.
He died of heart attack in 1966,
Indira's hands on the seat were fixed.

Though, this brought chaos and inflation.
Congress Party were to be the only protection.
She began a program to help poverty decrease.
Indira wanted her program in effect, she wanted economy to increase.

The start of the Punjab crisis was the foreshadowing of her life.
An area of Punjabi-and Hindi speaking regions, violence with knives.
Punjabi wanted their language as statehood (only Punjabi spoken) of
 the area.
However, Hindus wouldn't oblige, this carried on!

No solution was found, this kept on till her death.
Bangladesh war and Pakistan war, caused India a bad health.
Then 1973 came, Punjab couldn't stay quiet;
Riots and speeches were their alliance.

Indira Gandhi enjoyed her power,
It was greater than her father.
She was now a grand-mother.
Three children, "goo-gah" they uttered.

This was the year of depression.
India was poorer, what were her intentions?
Everyone wanted her to resign.
She called a State of Emergency, everyone came on her line!

From 1975 to 1977, India became a country of communism.
She felt as if she was at the top of the prism.
Sanjay came forth head on.
The results brought back the sun after dawn.

Emergency ceased liberty and freedom of all.
Even with 3% decrease of inflation, everything was not a ball.
The population was in control,
Sterilizing males was on role.

Elections of 1977, she learned her lesson.
She lost to Janata Party, harm came to her passion.
They convicted her of corruption.
She was put in jail, her life's short interruption.

Mororji Desai was the PM, but for 2 years.
He made India in a worse position, people had tears.
1980, history was made in the elections.
55% of the whole population voted, what an impression.

Indira Gandhi was back in the front seat.
Though, Sanjay, her younger son died, riots were the treat.
Rajiv took over on Sanjay's projects,
For he'd be the next PM, his opponents would regret.

The conflicts of Punjab came to the climax.
They started plotting a plan, did she have something to try next?
The day of October 31, 1984; this was her doom's day.
She would meet her husband at 9:30 am, to be near the River Gange's
 bay.

She left for her meeting that morning.
Without a jacket to prevent the shooting.
She landed in the hospital - later.
Her death was fire for Sikhs - who betrayed her.

Rajiv had the job even if he didn't want it.
Seven years later, he'd follow the same death at the seat.
He was a change from Indira Gandhi, his mother.
His ways were different than others.

She was the only PM to be in that position for 18 years.
She saw through the 1920's to 1980's, cheers!
Indira changed India immensely,
It is now in a best position economically.

She promoted science, technology, and higher education.
She had the courage and the confidence for India's population.
As people said, "Indira is India; India is Indira!"

Troublesome Times

The stock market had just crashed.
This was a sign that the economy had trashed.
Workers had been laid off.
Our lives were no more at the top.

Businesses were so confident that they began over-production and
 expansion.
The profits made were a form of distraction.
The change was about to arrive.
Life had made a quick turn and everyone had to learn to survive.

The first time it occurred, it was called a Great Depression.
Those were the years we had to make a good impression.
It was a hard time for all of us.
We had to keep ourselves from making a big fuss.

Our lives then were devoted to our needs.
We did not have many leads,
But we survived those awful and harsh days
Because we had many alternative ways.

We thought of causes for this lifeless game;
In our minds five had come.
One was that Canada depended too much on natural resources.
We had to fight and win with outside forces.

Profits were our goals.
These words were now printed on our souls.
However, we went too far.
We were stopped by a huge bar.
This might have seemed like the end that led to a wall,
But wait, there were many other calls.

Second was too much dependence on Uncle Sam.
Canada might have felt pressured by U.S. as though it was taking an
 exam.
Then when the American economy was in trouble,
Our problems were now doubled.
We had to find a way out,
But we could not fly like birds to go south.

Third was the high tariffs that discouraged international trade.
This slowed down trades with other countries, there weren't any more
 parades.
Other countries were not able to buy products because of high prices.
This left many products in large sizes.

Fourth was too much credit buying.
Afterwards, the people might feel like crying
Because there were too much interest rates.
This was now worst than the states.
The item didn't cost as much,
Prices on products bought from credit were terrible, people didn't
 want to touch.

People who couldn't pay the price were in very high debts.
This is why they didn't buy any more products.
Workers then were laid off.
We were in a position which was very soft.

Fifth was too much credit buying on stocks.
It was an easy way to make money, like they were taking casual walks.
There was a lot of confidence in the beginning.
Once the stocks began falling, no one was any longer winning.
People then sold them as quickly as they could.
They lost confidence and felt that they were no longer wearing a
 hood.

There have been many other depressions,
But they were called recessions.
These lasted for a few years.
Even so, they seemed to bring tears.

Since 1989 we have been in a troublesome time.
Our lives have been lower than a dime.
We are doing the best to survive.
The hard work will do better for our lives.

We had an election on October twenty-fifth.(1993)
The new prime minister will help our sadness to lift.
The plan he has will change the direction of our lane.
We might be saved from turning insane.

From the great depression, we've been worrying if we'll have another
 recession.
We have been through many of them, some were the government's
 concessions.
There are many reasons for businesses to slow down.
Sometimes the government wants us to get a wound.
This is because the prices are rising.
The government is not hurting or abusing,
But if prices go too high we can have an inflation.
 There's a chance of a recession which results in loss of confidence for
 the whole nation.

There are times when we have so much confidence.
This can have a lot of significance.
Once we are full and satisfied,
The businesses will be terrified.
Then workers will be laid off.
People are not able to pay their debts and no one has the last laugh.

The five reasons I gave for the result of a Great Depression.
These are a few causes for many other recessions.
When the time will change, no one knows.
We must always be on our toes.
Our lives depend on what we do today.
We should not wait to do the improvements next Monday.

Happiness and sadness are part of us.
We must learn to accept them and not make a big fuss.
 I hope you all learned something from this
And not just looked through to have the main points missed.

Within Reach

Not too far away
A bright light shines
Tells you that you'll get there even if in delay!
Everyone has a clock and their own time.

You might have complex worries and fears
Where you'll feel angry and want to give-up
Every night, your eyes will be full of tears
But, one day you might win a big prize cup.

There will be obstacles in your way
These you'll pass by quick
Then, walls where you won't know what to say
There are many other paths that are thick.

Some days you will know where you're going.
Other times you'll be totally uncertain.
It's up to you if darkness is in your mind; disturbing.
The other option is to drop that curtain.

The world is full of different colours.
Where you'll see bright shades or dark ones.
There are many people that can be role models.
Many ideas and inspirations will be in sight.

You'll have many goals to conceive.
Many dreams to cease.
You will have to learn to believe.
Because it's in your heart and within reach!

Perhaps

Perhaps… if all children were born equals.
 If every family was complete.
 If there were no separations.
 If children were not cruel to others.

Then, maybe life would have been easier.

Perhaps…. If there was no puberty
 If the heart did not know how to cry.
 If decisions were not important to make.
 If papers and tests were not graded.

Then, maybe growing-up would have been easier.

Perhaps…. If each found true love.
 If there was no such thing as money.
 If children were born grown-up.
 If there were no lies.

Then, maybe fights would have been easier.

Perhaps… if there was no violence.
 If atomic bombs were not created.
 If locks and keys did not exist.
 If fear was never faced.

Then, maybe freedom would have been easier.

Perhaps…. If muscles did not matter.
 If beauty only existed within us
 If all died only at the age of 100.
 If worrying of weight and illness was unnecessary.

Then, maybe aging would have been easier.

Perhaps... if there was no garbage.
 If pollution was not created.
 If all diseases were terminated
 If poverty did not exist.

Then, maybe this would be a perfect world.

Perhaps....,perhaps – so many things could have been.
But, they weren't to be.
Perhaps, it only matters how one sees the things that are.

People

I believe that you meet a zillion people
In the world before you die.
When you die, you die without a heart because
Each person you met has a piece of your heart.

Secrets

What is in one's mind,
Only one will know due to time
Life is like a mystery
Every second is making history.

Our eyes are in the darkness
For we do not know the future's brightness
There are secrets held far from our reach
We must search for them for God is to teach.

One's mind is like a maze
It can drive one mad or in a daze.
What one thinks, is one's secrets
These make a person more mysterious.

Past

Forget about the past,
It has gone.
What happened
Is now finished.
What didn't
Will always remain a mystery!

Wish

Close your eyes
Make a wish.
Hope to God,
He let's you live.

Future

I wonder when my dreams will come true
I wonder when I will reach my goals
I wonder what lies ahead in my future
I wonder if there really is Destiny!

Sometimes life is full of happiness
And other times, darkness is everywhere
I want to do a lot in my life
But at the moment I am in confusion!

I want to do it all at once
However, I know that this is not possible
I have to learn to live one day at a time
But, then why do I feel lost?

There is so much I think about
There is so little time
I have so much to accomplish
I wonder if my life will be long enough.

Life has many surprises
It has all that we need
The only thing is that we have to search for it
Some people find their Destiny, others die looking!

Suicide

Suicide is one way out.
Hope it's not your last real chance.

I Know That I Love You!!

I don't know what I do wrong
You are the One I know I love
I sometimes wonder why I have these feelings for You
However, I become confused and troubled!

I know that if You are pleased of me,
I could have all
However, I also know that this is not the right reason
For I love you for whom you are!

I know I want to see You
I am curious of You
I do not know if I am qualified
For I do many bad deeds!

I apologize for those, but that is not enough
I don't learn from my mistakes
Opportunities will be lost for this reason
I wonder, will I ever be legible?

I hope my love for You is loyal
For I don't want this dream to die
I know I Love You,
I just don't know if You do
Because of my bad attributes

I say sorry a million times
I pray every day
However, I know that this is not enough
I just don't know what to do
But, I do know that I Love You!

I hope you hear my heart beat quicken at the thought of You
I hope You know how I feel about You
I hope no one goes through this torture of waiting for You
For I know the pain of not being able to see You
 I just know that I Love You!!

Can You?

You can day dream
Ask as many questions
Take a lot of risks
Play more than work

You might be talkative
Or enthusiastic about everything
Could be intelligent
And artistic

You might think you are strong
And fearless
You might kill a dragon
Or fly faster than a plane

But, can you take opportunities
Or fantasize about reality
Do you have the strength to kill a fly
Or fly a kite

Do you believe that you can learn from your mistakes
Remember your experiences
Teach others the knowledge you have
Can you not give-up!

Doubt

Even though you are so close by to me
You seem so far away
I want to say, I love you
But, I'm afraid to anyway

I might not lose a friend
I might not gain any more
I want a close friendship
But, first we have to be good friends

You seem to hide your feelings
I tend to speak them out
We seem so different
But, people say that opposites do attract

I don't know if any chemistry will occur
But, I know I'll never forget
I want to say, I love you
But, I'm afraid to anyway

I believe you can read my face
The words are written all over
We should talk more often
You see, I can't read your face

Time is running out so fast
I can't seem to keep up
I'll try my best to do whatever
For I don't want to regret the unexpected

Even though you are so close by to me
You seem so far away
I want to say, I love you
But, I'm afraid to anyway!

Meaning of Life

Life is no longer important, my goal is.
I won't live for life; I'll live for my goals.
My goals, my dreams, my determination
And ambition are my happiness.
Life has nothing to offer me,
But my dreams have life to offer.

Promise Me Something

I promise to succeed.
I promise to reach my goal.
I promise to think.
I promise to work hard.
I promise to read.
I promise to learn.

I promise to make next year the best.
I promise to do now.
I promise to enjoy life.
I promise to read the Bible.
I promise to learn something new every day.
I promise to build new things.

But most of all I promise to dream!

Far From Reach!

An intense feeling that keeps screaming
An imagination that keeps dreaming
A brain that says stay away
Because you are a needle in a stack of hay!

I know I can't say 'I Love You'
I know you belong to someone too
I, however can always keep hoping
That some day I'll come and drop in

I'm a girl with strange feelings
This is my first time in these dealings
You are a person with such intensity
But also aloof with a lot of sensitivity

You seem to be lost in the world of glamour
Where things are fought in such terror
A place where looks are important
Where heart is merely a token

Dancing in the rain
Muscles coupled with a brain
I feel I am too far away
But, I'll meet you some day

Help! I think I need aid
My imagination is going insane
Looking at your picture
There is sadness with joy; a mixture

You are making my heart stronger
This will make my sight look more broader
Please respond to this letter
If possible, through a poem which is better

I am not tall or thin
I am not a great poet who'll win
I am just Sabrina
Who thinks she found her idol, you: na!

This is a challenge I must pass
It will determine my strength in many tasks
I believe you are my confidence and motivation
Oh God! You are my inspiration

Your eyes show many experiences
With a bit of mischievousness
Hidden are many thoughts
These must be a journey of life you sought!

This sounds as if I'm in love
I'm only confused which has risen above
I just want to see you smiling
For these are only a child's words arriving!

My friend once wrote a few words
 A letter with musical chords
This was sent to a movie star
A response never given; he must have been made out of tar

I don't know if you'll answer back
But, I will not give-up, I will attack!
I am stubborn and blunt
Who'll write a poem every month!

These poems might not be great
But, will be a trait
From within my heart
Feelings that were once fought

Now, it's up to you
Will you not write back too?
I know you receive 300 letters a day
But, each one is different, don't you say?

These letters are from somebody
A person with a soul and body
I am not trying to make you feel guilty
I just want something form you, quietly.

Don't ask me what I see in you
You are a person; like me too
I guess, you're different
A movie star, brilliant!

Till next month and time
Hope these days go well and steps you climb
Awaiting for your respond
A girl is in fond (of you of course!)

Infatuations

Close your eyes
To see many ties
An ocean with waves
A place with caves!

Secrets every person keeps
Sometimes one can't sleep
Times where work is all
To cover pain with a shawl

You seem adrift
In thoughts that shift
A face with experience
That gives great influence!

A body fit for life
A murderous sight
Moves that break bones
To anyone that crosses you in a high tone!

Life is filled with ups and downs
But, one has to wear one's own crown
Everyone is different in this place
If lost, no one will find your trace

You have to set your own goal
To fill your own bowl
One must focus on an aim
For life is similar to, "No pain, No gain!"

Taught are many lessons
A belt that God fastens
Through hills one must pass
One must be made of gold, not brass

You come in my dreams
Near long and narrow streams
To teach me to fight
So, I can walk alone at night

You trust with hardness
You share thoughts with God with easiness
You have your mom as a best friend

You hold a possessive bond
I know a lot about you
Though, you have the right to know about me too
You should know who writes to you in such stupidity
But, they say that loves comes out with great credibility

Don't think of this as something said wrong
For a love shared between 2 friends; a bond very strong
You might not think of me as a friend
Though, a person to put a smile on others, is more than a trend

You work hard to please others
To let others forget their sorrows; to be brothers
You show the meaning of life
Which at times feels like a knife

There is a lot to do
Reality is gone insane too
We (people) must work together
To teach others to share a bond forever

I think I've said enough
I hope you stay tough
For it's a long way to go
A walk that might be slow

Till next time, next letter
I hope to receive one that is better
I am stubborn and blunt
For I will write every month!

If I Were.....

If I were the sky;
I would never allow night to fall.
If I were the tree;
I would never allow the leaves to die.
If I were the rain;
I would never allow cities to flood.
But I am me;
What can I not allow?

Reach

If I open up my eyes,
I am hoping to survive.
If I begin to take a few steps,
I am hoping to reach far ahead.

Nature

I am the river.....that
Reminds others of freedom.
I am the wind....that
Tells others to go on with life.
I am the light.....that
Shows others to have a goal.

I am the fire...that
Boils ambition in others.
I am the ice...that
Tells others to be patient.
I am the thunder...that
Reminds others to fight for their rights.

I am within anyone
Who dares to dream!

I am the stars...in
Each mother's eyes.
I am the strength...in
Each mother's hands.
I am the pride...in
Each mother's heart.

I am the child that
Every mother desires.

Life is...

Life is like a river
You don't know where it will flow.
Life is like a road
You don't know where it will turn.
Life is a mystery
It might one day be solved.

It is a dream
That might one day be real.
It is a goal
That might one day be reached.
It is a struggle
That seems to never end.

Can't You Hear..........

Can't you hear,
God is whispering.
Can't you see,
He is speaking.
I am happy to say
That I am here to stay!

Have you ever,
Had a taste of your dream.
Have you ever,
Seen your eyes gleam.
I am happy to say
That I am here to stay!

Have you ever,
Felt your heart skip a beat.
Did you ever,
Want to give yourself a treat.
I am happy to say
That I am here to stay!

Can't you hear,
The wind blowing.
Can't you feel,
The chill flowing.
I am happy to say
That I am here to stay!

Sunlight

To see light
One must learn to see dark

Money

Gold is where the corn lies

Acceptance

You accept failures
Success will accept you

A Guy in a Corner

There is a guy in a corner
Standing all by himself.
Listening to the world,
Listening to the hearts.

There is a guy in a corner
Waiting for someone.
He wants to be loved;
He wants to laugh.

I am learning the ways of the world.
I am learning the ways of the people.
I am learning that I hate the world.
Yet, I love it somehow.

There is a guy in a corner
Standing all by himself.
Listening to the world,
Listening to the hearts.

World Fever

The world is black and white
Colors are within the heart

Love

Love is like water,
Sometimes thick and
Sometimes thin
Sometimes high and
Sometimes in a low!

I Love You

I love you,
I want to tell you many times.
I love you,
My heart is with you shining bright as sunshine.
I love you,
I want to spend the rest of my life with you.
I love you,
I hope you feel this way for me too.
I love you,
I don't know what else to say.
I love you,
I have confidence in you, the same for me I pray.
I love you,
Nothing else seems important to me.
I love you,
I want this pain to go away, I want to be free.
I love you
I hope you say these words to me some day too.
You have drawn me closer to you,
I love you! I love you!

If You Promise

If you promise the land, I will stop!
If you promise the sky, I will stop!
If you promise the sun, I will stop!
If you promise the stars, I will stop!

Stress, fatigue, and boredom are my problems.
These are part of my life; as shown in my albums.
Worrisome is said to be my hobby,
Romance is shown best in the movie 'Bobby.'

If you promise the light at the end of the tunnel!
If you promise God waiting for me!
If you promise happiness throughout my life!
If you promise love, I will stop!

I Choose!

The river is blue.
Sometimes you see it green
Other times you see it brown.
I always see it blue!

I choose to see it blue.
I want to see it blue.
I like to see it blue.

I choose to live the way I live.
I choose to be the way I am.
I choose to do what I do.

I choose to open the door I want to.
I choose to weave the dream I follow.
I choose to walk on the path I want.

I am given the capacity to choose.
I am given the skill to decide.
I CHOOSE TO LIVE THE LIFE I am given!!

Words

Dream,
 It makes life easier.
Hope,
 It makes miracles easier.
Think,
 It makes problems easier.
Wish,
 It creates paradise.
Love,
 It creates happiness.
Feel,
 It creates emotions.
Listen,
 It gives creativity.
Talk,
 It gives heaven.
Experience,
 It gives knowledge.

Search

Search for money
You'll find sadness;
Search for death
You'll find life;
Search for God
You'll find Him inside yourself!

It's Time

It's been a long time
I now have written
It's been a long time
I still love you with all my heart
It's been a long time
I can't get over the first kiss

It's been a long time
I miss you still so very much
It's been a long time
I need to feel your closeness
It's been a long time
But, my heart was yours forever

It's been a long time
...going out on romantic dates
It's been a long time
...sitting on the sand near the lake
It's been a long time
...talking to each other, opening our hearts.

It's now the time
To meet again and share our thoughts.
It's now the time
To love each other till death due us apart
It's now the time
To ask you this very question:
Will you marry me?

Stranger

This is the first time you have opened up to me
I have seen myself falling in your arms
You are the only one who understands my pain
You reach out, but can't say anything!

It's been such a long time
I feel the first in line
You have shown me your eyes
Now, you have shown me your smile, you've heard my cries.

I'm in love with you so much
I shiver with your touch
I have given you my life - my heart - you're to drive.
I need yours to survive!

You're my confidence, you're my faith, my destiny!
You are everything to me!
I want to live for you only,
I want to die with you quietly!

I have given you my life
I have named myself your wife.
I am your slave
And you are my craze!

I hope there will be a day
When you will say someday,
"I love you!"
I hope that day comes soon!

Nothing seems important to me anymore.
I hope you are somewhere with open doors!

I Want To.....

I want to fly like the bird,
to touch as much of the sky.

I want to feel like the breeze,
the softness of the leaves.

I want to fall like the rain drops,
 on the warmth of a flower.

I want to float like the clouds,
to many seas, land, and destiny.

I want to freeze like the ice,
so happy moments stay and sad ones slip away.

I want to change like the leaves in autumn,
to learn new ideas, thoughts, and experiences.

I want to stand like the tree,
as tall as I can to the failures and success ahead.

I want to grow like a child,
to take in as much as the world offers.

I want to be free of all the -
worries and the responsibilities.

I want to do all without any hesitation!
I want to live my life!

I want to feel like a queen,
to travel the world
to travel the universe.

I want to live life -
as no one has ever before.

I want to live life -
as though there is no tomorrow!

Friends

I make friends to keep them forever, which is eternity.
Even if a friend does whatever in his power to break my heart
Or kill it; I will be there fore him whenever he needs me.

Pain of Life?

Life is a bed of thorns,
Learn to sleep on them.
Learn to handle the pain,
Life will one day reach its goal.

So Much

There is so much to experience
There is so much to see
Sometimes, things are pulling me
This way and that a way:
That I am lost
I want to see and feel everything
That it scares me.
I want to feel life
...Experience life
.................Drink life to the fullest!

I don't know what's ahead
It could be something happy or
Something sad.
It could be a surprise that
Would make me angry.
But, at least I'll know that I will experience it!

For You

I love you!
You are my life.
You are every breath in this body.
Every tear from these eyes is yours.
Every step I take is to come near you.

I love you!
You are my destiny.
You are the prince in my dreams.
My death, my goal, my soul is you.
My heartbeats show my love.

I love you!
You are I.
You are every part of me.
I see you in every man.
I sense you near me every second.

I love you!
You are my husband!
You are my soul mate!
You are my lover!
You are my friend!
You are my life!

He

I fell in love.
I see him everywhere.
I can feel his presence near me.

He sometimes touches me.
Drowns me in his eyes.
His look is deadly.

Yet I am so far away from him.

When.....

When dreams shatter -
....like a broken glass.
When the heart breaks -
....like your favorite toy.

Life seems like an endless journey.
There doesn't seem to be a road turning.
It feels cold and lonely,
The silence climbs in you quietly.

When you feel trapped -
....like a bird in a cage.
When life doesn't seem to go your way -
....like a boat in the water in a storm.

You want to talk to someone,
But you feel so lonesome.
If life was easier to handle,
But responsibilities keep increasing.

When dream shatter -
....like a broken glass.
When the heart breaks -
....like your favorite toy.

Meaning of Life

Life is a journey
To be taken slowly.
Life is a path
That you must lead only.

It brings opportunities
Where none are foreseen.
It brings luck
When troubles seem your future.

It is a challenge
For which one should not give up!

A Dream Within A Dream

Caught in a world far from our reach.
In a dream, a fantasy of films.
A dream of a guy and a girl.
It seems to have different twists.

This is where I meet him
A man I love, but never see.
The Romeo who could steal my heart.
The lover who knows me inside and out.

He reminds me of Shah Rukh Khan (Indian Actor)
The guy who one day will carry me across the throne.
He understands me.
He touches me like no one else.

He's like no one I have ever met.
He's filled with jokes and tricks
But his eyes say more than his smile.
He had the experiences of life the hard way.

Found

A girl once lost
In the shadows of the past!
Has now been found.
Open to the rays of tomorrow!

You

You are like the breeze
Whispering by something in my ear

You are like this sea
Waiting patiently for my time to come.

You are like the bird
Flying where life is taking you.

You are like the tree
Standing tall in front of success and failure.

You are like the mountain
Setting a goal to reach the sky.

You are like the flower
Wisdom passing by like the scent to all.

You are like the sun,
Shining with happiness no matter what comes in your way.

You are like an umbrella,
Giving comfort to those who need it.

You are like the swing,
Giving a ride to those who plan to give-up.

You are like the curtain,
Listening to others problems, but keeping them from the world.

You are like the grass,
Being stepped on and taken advantage of without a single word.

You are like the music,
Hoping to be heard by all some day.

You are like God to me,
Understanding, trustworthy, and there for me whenever I need you.

Feel

I can hear;
I can see;
But don't touch me
Because I can't feel.

So Close, Yet So Far

I have a wish.
I have a dream.
I have to reach far,
I have to reach high!

Love

Love is a relationship that
Never seems to end.
It is a friendship with
A strong bond.
Love is a memory of
Joy and happiness.
It is a strength of two
Close friends.

The Star of Light, The Sun

The darkness brightened in one's heart
An endless light of God's true art.
Every day the sun arrives with light,
Driving darkness far away from sight.

It stands out like the one in power
The planets circle the sun every hour.
It gives us heat and light to see,
It feels as though it surrounds only me.

The star of light makes the world shine,
The sun will not disappear with time.

I Dream

I dream,
 Whenever I am happy.
I dream,
 Whenever I am sad.
I dream,
 Whenever I am angry.
I dream,
 Whenever I am in love.

Dreams show me light
Where darkness once was so bright.
Dreams take me to unexplored places,
Where I see a thousand faces.

I see animals talking.
And teapots are dancing.
Where flowers sometimes fly
And land seems to cry.

I dream,
A place where everyone is equal.

Be There For Me

He'll always be there for me.
One shout,
He'll carry me through my problems.
One shout,
He'll say what I need to hear.
One shout,
He'll make me laugh.
One shout,
He'll make my worries disappear.

Competition

There are things that you want so much
And you can't live without their touch.
This is so,
When your heart is filled with feelings that are low!

You have so many goals planned
You have had so many dreams in the times passed.
You sometimes feel scared of the fact that some won't come true
At times you feel so confident, that all will have come true too.

However, sometimes it hurts
Sometimes things don't seem the way they should, you become alert
You think of giving up,
But that is not the case as such.

For you want your dreams a reality
You can't allow life to beat your mentality
Competition is the only way
Your future is in your hand, they say!

Let's work together
Let's keep going even if it is forever!
The only way to go up, is to climb without hesitation
However, the excitement will always be there through competition!

Flowers

There are two flowers
One is dead, the other one alive.
Which one would you choose?

Light

The sun was shining
I saw bright wide smiles on faces
The sun disappeared!

Home

Where sky and sea meet
Life begins in a new place
Hope and peace are found!

The Hot Fire

The harsh red fire blew
Towards us as though it was
About to burn us up!

Is It Love?

We have been friends for so long
I have told you many things
We have danced and listened together to many songs
You were always like the wings
You listened to my problems
You gave me many advices to help me go on
You were always there for me
You were the only one who understood me
Was it love that was growing between us?

We went to places together
We traveled the world as one
I thought you were mine forever
I was the moon as you, the sun
There were barriers between us that were stopping us from thinking
 what we wanted to
Did everyone know that we were in love?

However, life had something else planned for us
We had to be apart from one another
Everyone was jealous of this relationship between us
I knew that our souls would be together forever
Is this love?

I always thought love was when two bodies became one
Where nothing was impossible and everything possible
Where problems could not survive in front of love
I thought the highest point in life was love
I guess I was wrong; this was only someone's dream
A person who got lost in the crowds
To whom lies were part of life and nothing else
Would you say that, this was love?

I want the old world back
However, there is too much violence and hatred
But, I know someday I will be part of my dream
And this world will cry in thirst for it
Then, I will say that Love is found and Hatred lost!

Double Trouble

There are two faces hidden behind my name!
It is hard for both to please and sooth.
If one is relaxed then the other is in a flame.
If one is happy, the other is in a sad mood.
I sense from them too many demands.
I feel as if I am being choked, but there are no hands.

There is one that appears in the day,
It tries to make me do things as pure as the ocean bay.
The other only appears at night,
And it makes me do things that bite.
I must learn to stay calm.
But, at times I want to scream at the sound of an alarm.

I want a life full of happiness and achievement!
I want my dreams to come true!
I want so much that it sometimes scares me!
I do not want to be the cause of my destruction!
I do not want chaos in myself!

There is too much to do and I cannot have worry thoughts
The time will come when one will get what it wants,
There will be a time when the other will gain everything.
Dreams will come true!
Reality will not be disappointed either!
This will be the time for the end of this double trouble!

Thoughts and Feelings

I think of the future
I think of the past
I do what I should in the present.

I sometimes am happy,
Sometimes sad,
Sometimes angry and
Sometimes scared.

What will happen to me in the future?
How can I be forgiven of the sins of my past?
Will I ever meet my goals or
Will I pass them without knowing?

These are my thoughts,
These are my feelings
These are the things that
Make each one of us unique!

A Glow Behind Closed Doors

I close my eyes, I see you
I feel the beats of my heart; I feel that I touch you
I breathe, I sense you everywhere inside of me, which is so true
You are like a glow behind closed doors!

I dream of you every day
I feel like screaming, hurray
I sense that I have you
You are like a glow behind closed doors!

You are the soul who keeps me alive
You are the sunshine of my life
You are the only person who stole my heart from me
You are like a glow behind closed doors!

You are the one who knows me, more than myself
You are the trust that holds me
You are like a glow behind closed doors!

The strength in my body needs you
My heart, which needs love, needs you
My entire life needs you
You are like a glow behind closed doors!

When will the door open?
When will the glow become sunshine?
 When will you realize that we are one!
You are like a glow behind closed doors!

Confession

Let me confess
I feel something for you,
I just don't know what to call it
Other than love!

Desire

I have felt this way for a long time
I now just have told myself
I can see my body against yours
My soul is diving deep into your eyes.

Life Must Go On

Forget about the past,
It has gone.
What happened
Is now finished.
What didn't
Will always remain a mystery!

Gold Is Glitter

I am so gold
So is my heart and soul.
I love to care
That's why I always share.

I am not perfect
But, I have the right circuits.
I am rich and loyal
Just like my land of soul.

I care for the poor
I give from my heart's core.
My home says all
My family is always my first call.

I glitter like gold.
I will not be sold.
I love to care
That's why I always share.

It's Not The End, But The Beginning

I have finally gotten you
Tied a knot of marriage with you forever
I see myself part of you too
I am going to leave you never!

Sometimes I feel as though I know you so well
At times I sense I don't know you at all
I am like a shell
And you are everything inside covering me with a shawl

You are the light within my eyes
The music in my every breath
There aren't within us any lies
Death is no longer a threat

My life is in good hands
Every dream is coming true
Filled with as much depth as the sand
A movie made by looking at the sky's color, blue.

I can't live without you
Giving me the meaning to dream
Seeing meaning in life going through
A chocolate cake with a cherry and cream

The flower has at last blossomed
No more lonely walks along the beach
We have at last crossed them,
The lessons teachers need to teach!

Friends

Things that seem fearful from parents
Which seem fearless from friends
These are the things that are fluorescent
And are these times, trends

Friends are related to you
They are there to help you when in pain
To share the happiness too
For parents this is not sane

They give a party for you when stress is built
Friends make you laugh when you are sad
Everything changes; life seems to tilt
Nothing seems wrong or even bad

Friends are like brothers and sisters
Encouragement is given and they believe in you
They don't tell you that you are an empty canister
You don't seem lonesome or are seen alone is your room too

Friends can never be lost
They will always stay in your heart
You will never have any sort of cost
Never will you be apart!

Meaning of Life

Life is a staircase
It gives you two options:
 To go higher or
 To go lower

I Have To

I have to do this
I have to do that
I shouldn't worry
I should just study.

Love is like....

Love is like a butterfly,
It takes time to open up to the world.
Love is like an angel,
Helping another to cross the river of challenge.
Love is like time,
You never know how you'll feel the next minute.

The Four Diamonds of Life

You are born,
You fare the light in everyone's life.
Fights with parents are part of teenage life,
This is when you feel you know all.
Marriage has come at last,
Adulthood is worse than you think.
You are a child again,
As old and with wrinkles as an elderly man.

Walk in the Park

No one ever said that life was a walk in the park.
It is a walk of a 100 years and
One must learn to walk slow and
Enjoy the experiences and the views.

The Cold Day

The leaves were rustling
As I began shivering
The wind was whistling!

The Silent Sea

The sea is quiet.
The birds fly over the waters.
The sea is awake!

Success

In order to reach the sky
One must learn to fly

Live

Live for the Present,
Not the past or the future.
The past is gone.
The future is yet to come.
Live life for adventure.
Live life for wonders
And treasures and pleasures.

The Young One

You are the one I was waiting for
You were the one who always smiled through the roughest times
I always thought my problems to you were a bore
However, you were always there for me, your face was brighter than
 the sunshine

You watched every step I took
You told me what to do and what not to
When I was down I felt happy by your look
You were brighter than the sky's color blue

Singing and dancing with your friends
Trying to make me laugh and enjoy life
You seemed like the mother and I, the child for which learning was
 sent
I would just like to say thank you for giving me part of the brightness
 of your life

Now that I know what is good and what is bad
No matter what, I will never give up
I will do my best and I will try not to be sad
I will try to cheer you up

I always want to see the brightness that you showed me
I always want to see your smiling face
I always want you to sing and dance
I will always be there for you, Young One!

In Control

You have me in your hands.
My heart is no longer with me.
My thoughts are in different lands.
I can't just leave this be.

How can I convince you?
What can I say?
That I like you.
I can't stop thinking about you each day.

He Reminds Me....

He reminds me of God.
He reminds me of Daddy.
He reminds me of my Heart!

He reminds me of my Shadow.
He reminds me of my Future.
He reminds me of my Past!

He reminds me of what could have happened.
He reminds me of what could happen.
He reminds of sorrow!

He comes in my dreams.
He comes in my thoughts.
He comes in front of my eyes!

He comes in the rain
He comes in the dark

He shows me laughter.
He shows me glow.
He shows me tears!

He stole my heart.
He stole my day.
He stole my life!

Work, Fun or Studies?

There are so many things to do.
There is so much work to accomplish
There must be fun and excitement too
Our studies cannot also be demolished.

We have to keep the house beautiful and clean
We need to cook, wash clothes, do dishes, brush.
We must be tall, hard, lean machines
In order for this to happen, important is trust.

Playing outside, riding our bikes
Singing and dancing, having fun
Doing parts from Hamlet, wearing tights
This is also important to make our life turn

In order to reach one's goals, studies are important
One needs to learn the meaning of life
One needs to discover one's goals in one's existence
This is to ensure that one's future is bright and in brilliance!

The world is waiting for the future
We still have a lot to learn, but also a lot to teach
We have so many children to nurture
We have the whole universe to cease!!